BUNCH OF HOCUS POCUS

78							

BUNCH OF HOCUS POCUS

An UNOFFICIAL Coloring Book for Fans of the Halloween Classic

VALENTIN RAMON

This book is not associated with or authorized or approved by The Walt Disney Company or any other owner of rights in *Hocus Pocus*.

Copyright © 2022 Ulysses Press and its licensors. All rights reserved. Any unauthorized duplication in whole or in part or dissemination of this edition by any means (including but not limited to photocopying, electronic devices, digital versions, and the internet) will be prosecuted to the fullest extent of the law.

Published by: Ulysses Press PO Box 3440 Berkeley, CA 94703 www.ulyssespress.com

ISBN: 978-1-64604-359-0

Printed in the United States by Kingery Printing Company 10 9 8 7 6 5 4 3 2 1

IMPORTANT NOTE TO READERS: This book is an independent and unauthorized fan publication. No endorsement, license, sponsorship, or affiliation with *Hocus Pocus*, The Walt Disney Company, or other copyright or trademark holders is claimed or suggested. All references in this book to copyrighted or trademarked characters and other elements of *Hocus Pocus* are the property of their respective owners and used for informational purposes only. All trademarked products that appear in the book are the property of their respective owners and used for informational purposes only. The author and publisher encourage readers to watch, rent, purchase, and support *Hocus Pocus*, and to patronize the quality brands mentioned and pictured in this book.

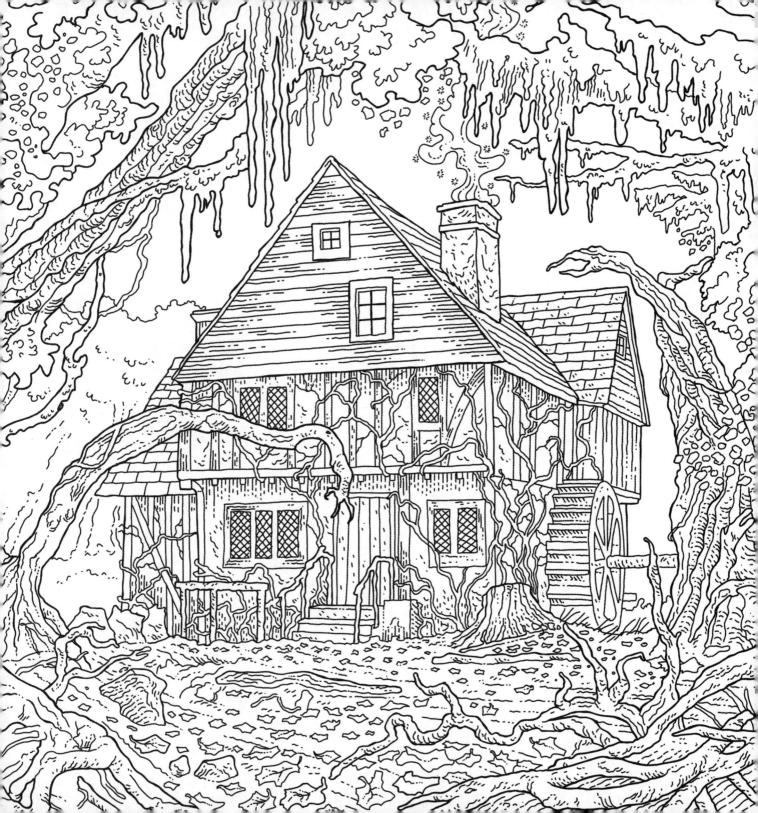

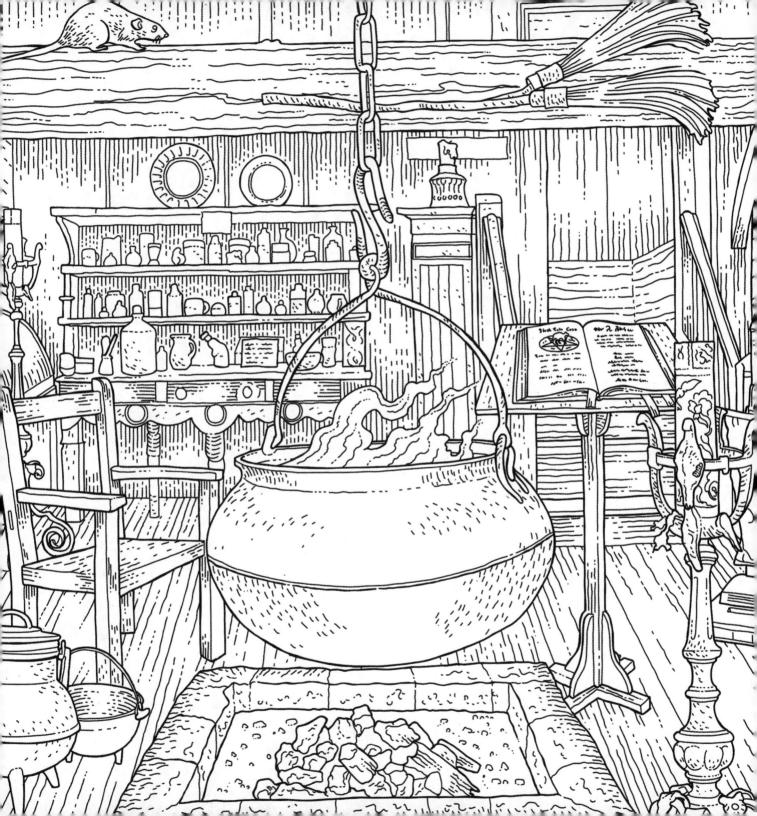

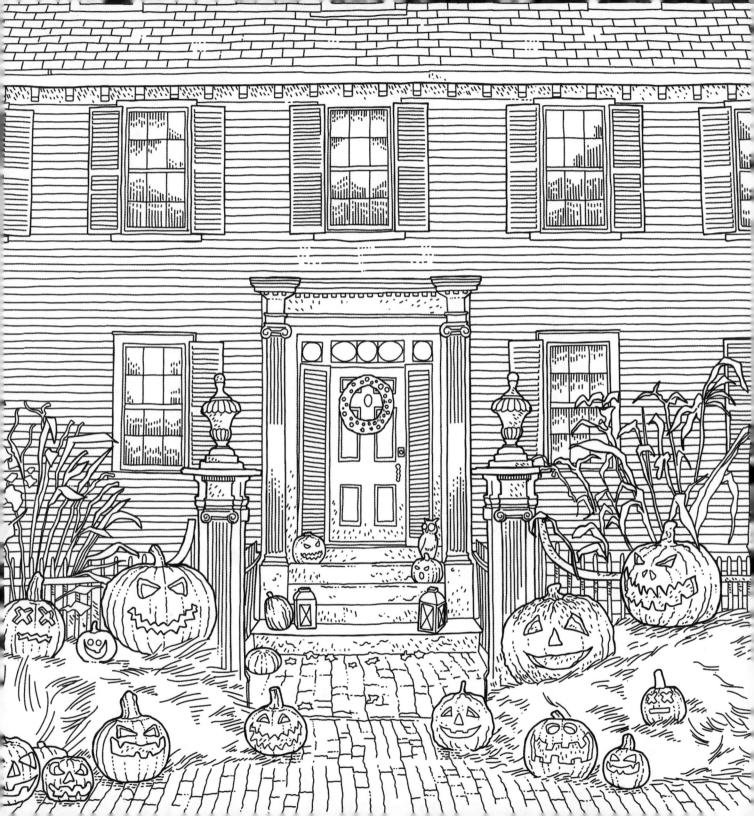

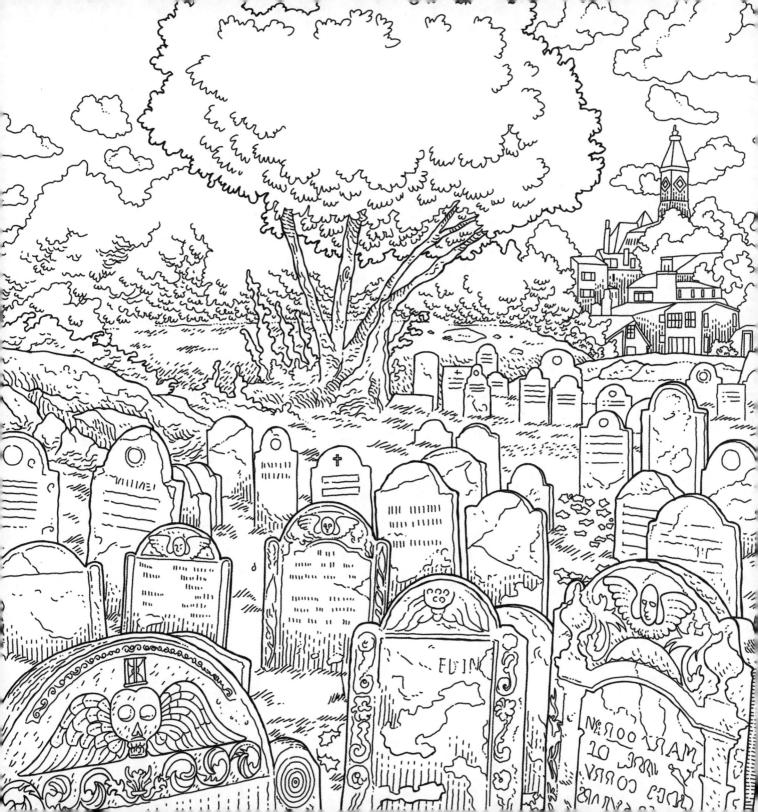

				A law	
프랑스 프랑스 마이지 :					
		경험 기가 있다.			

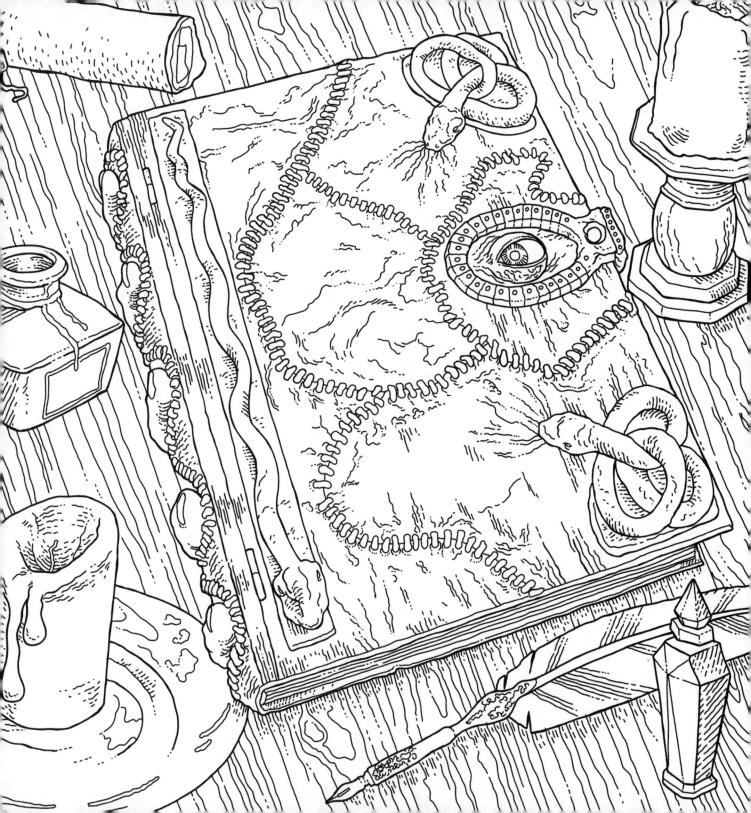

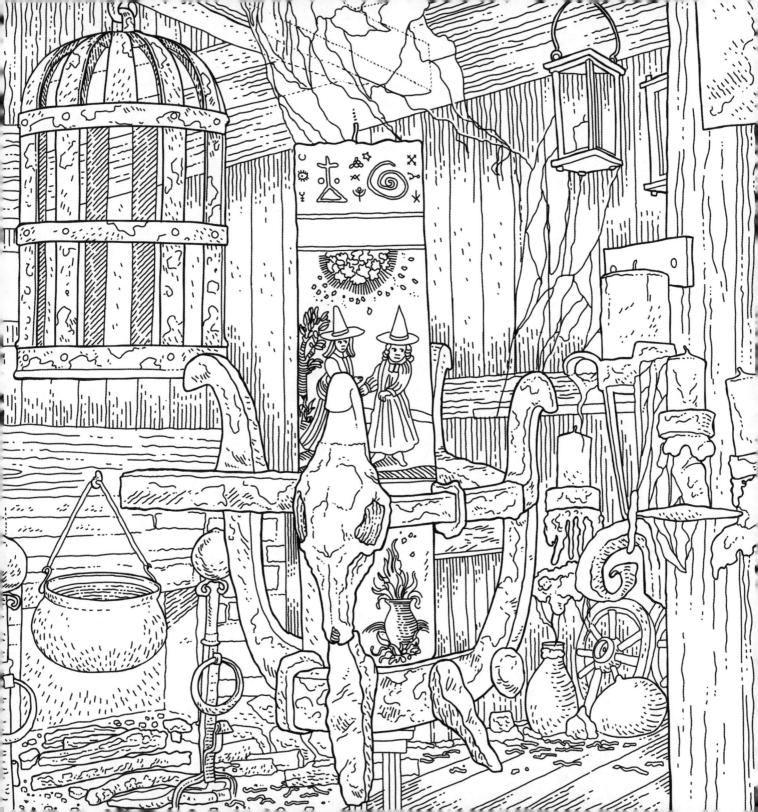

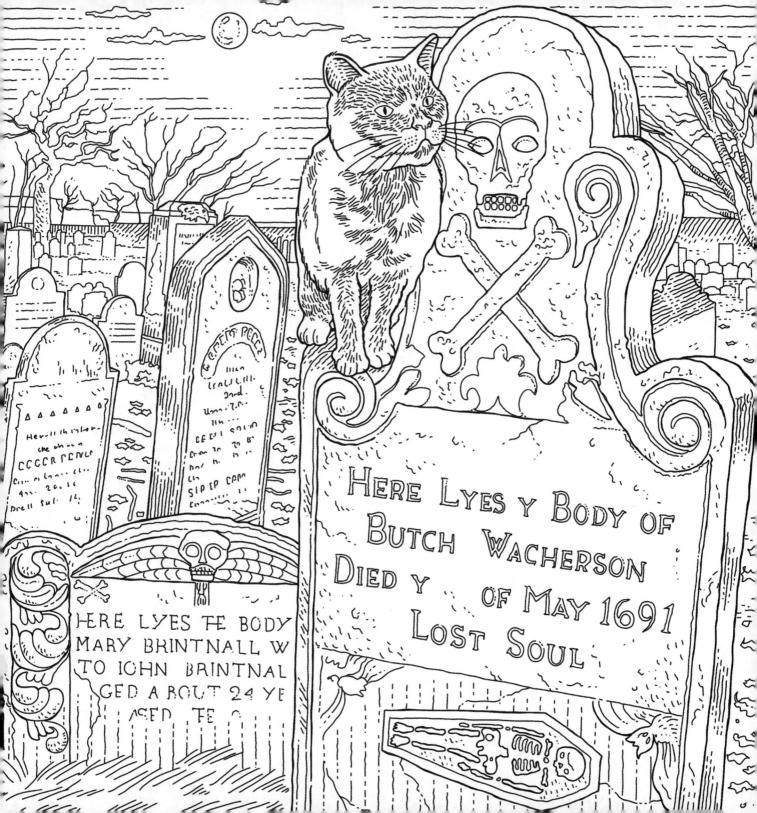

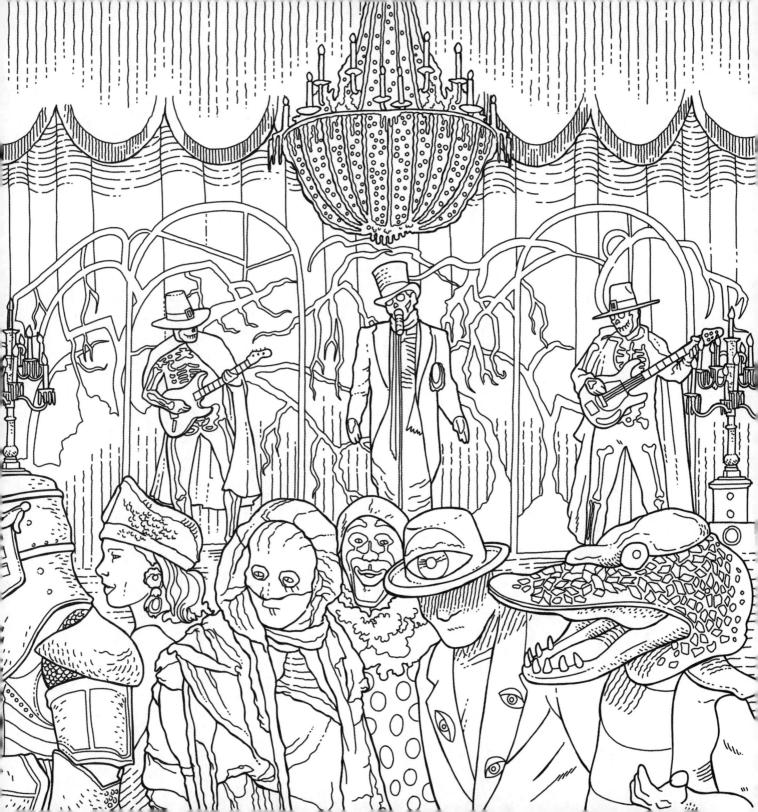

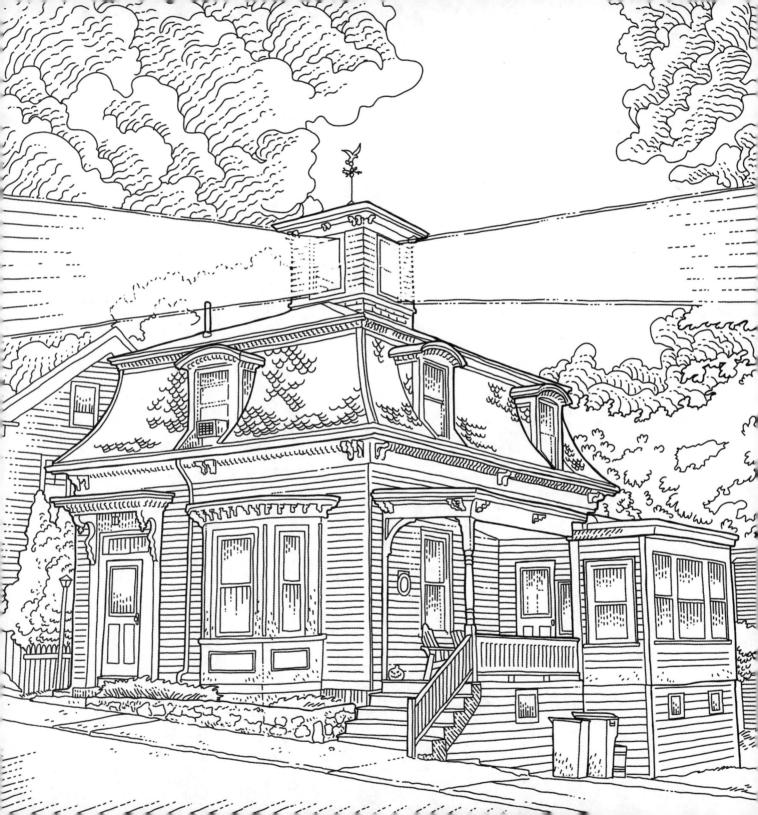

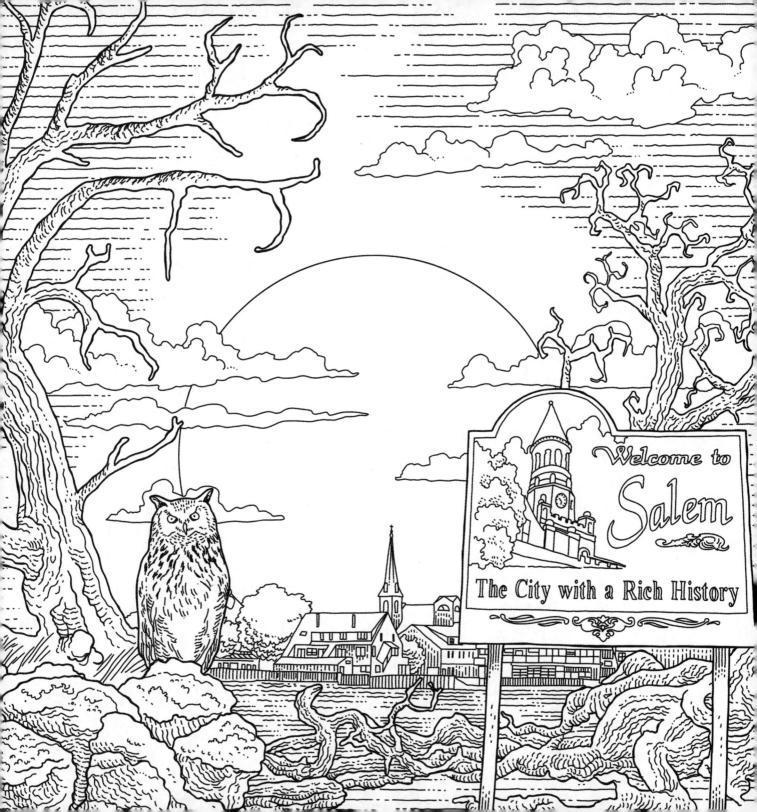

			1.5		

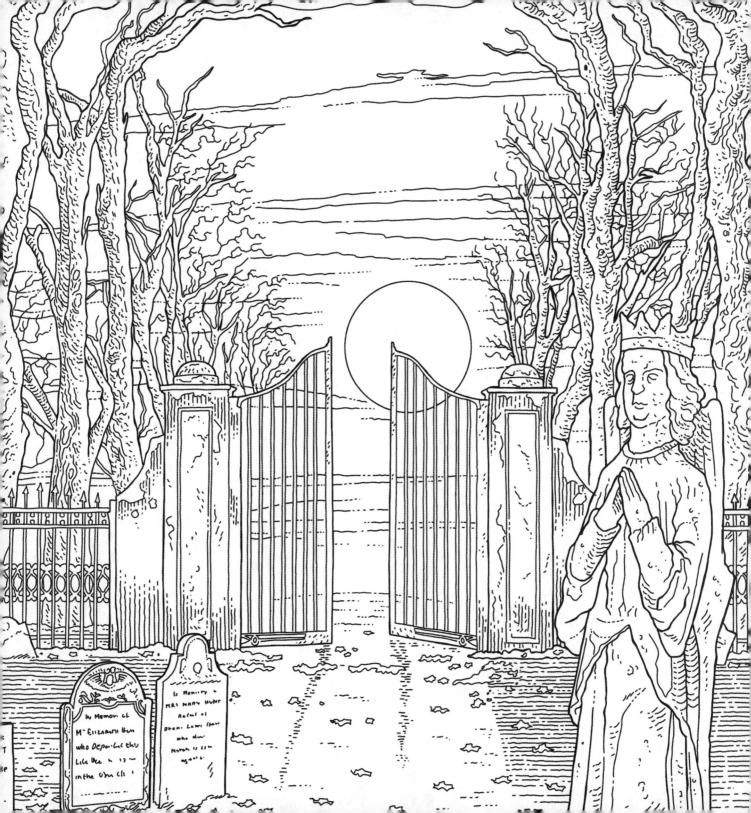

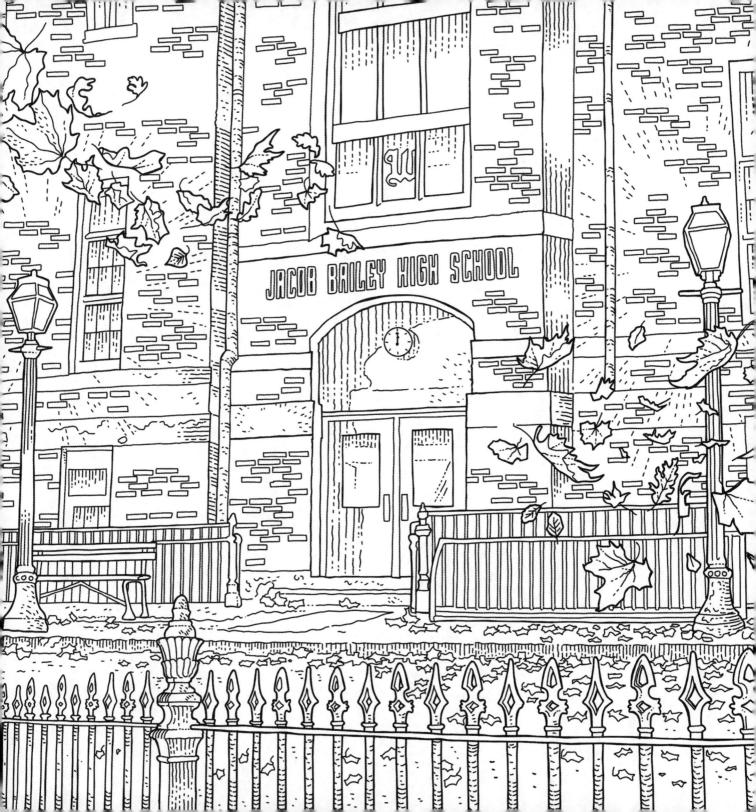

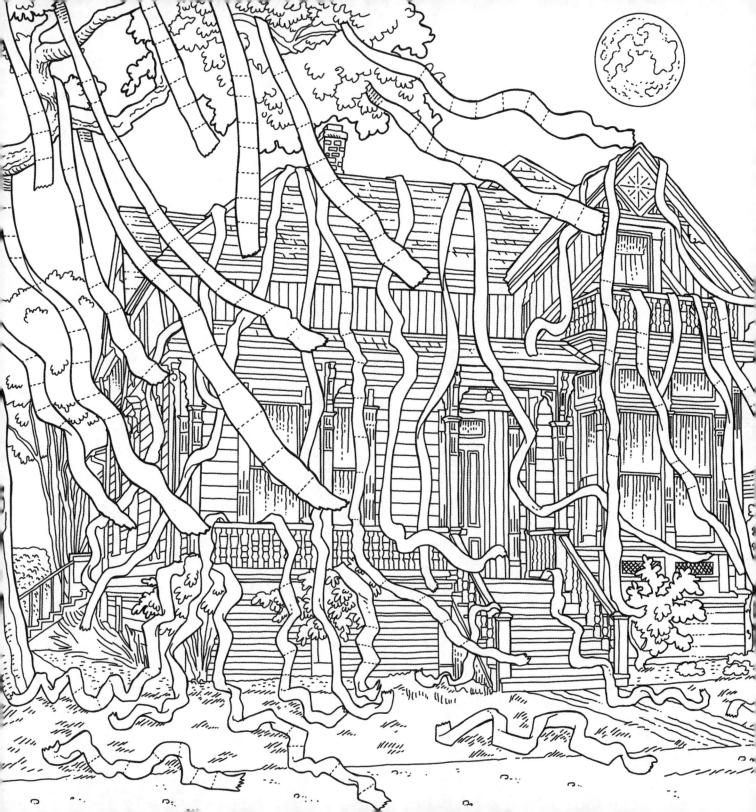

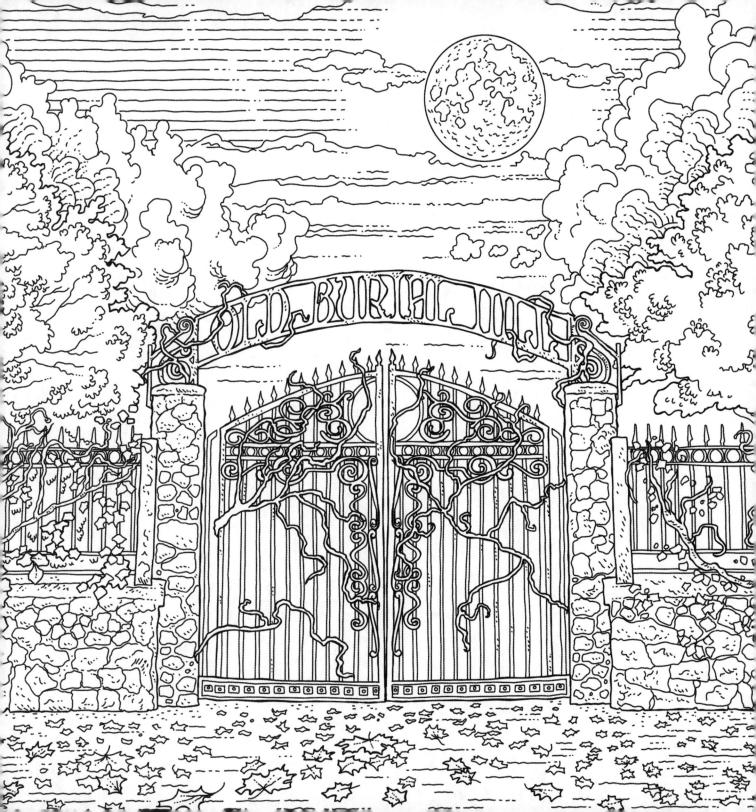

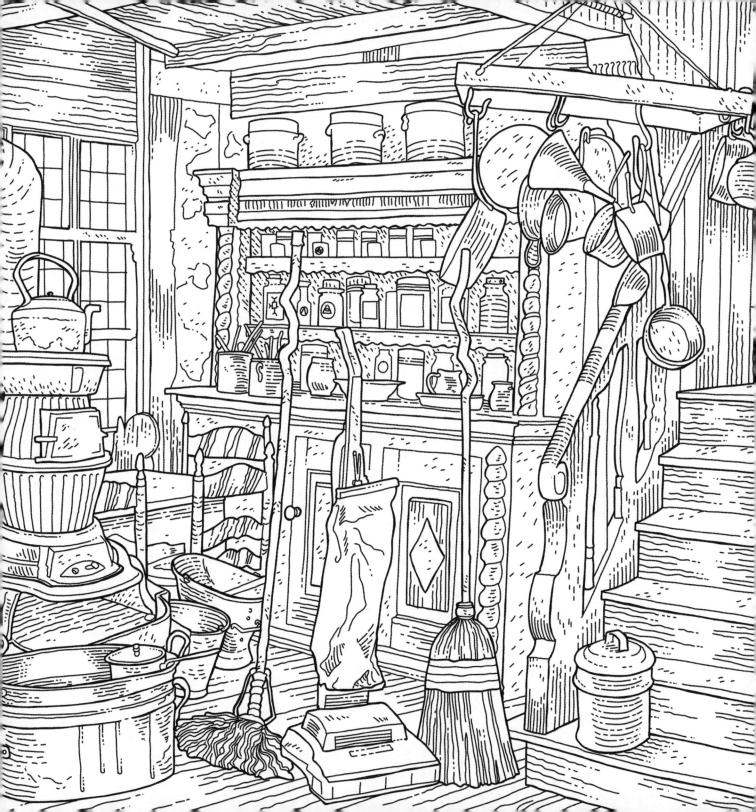

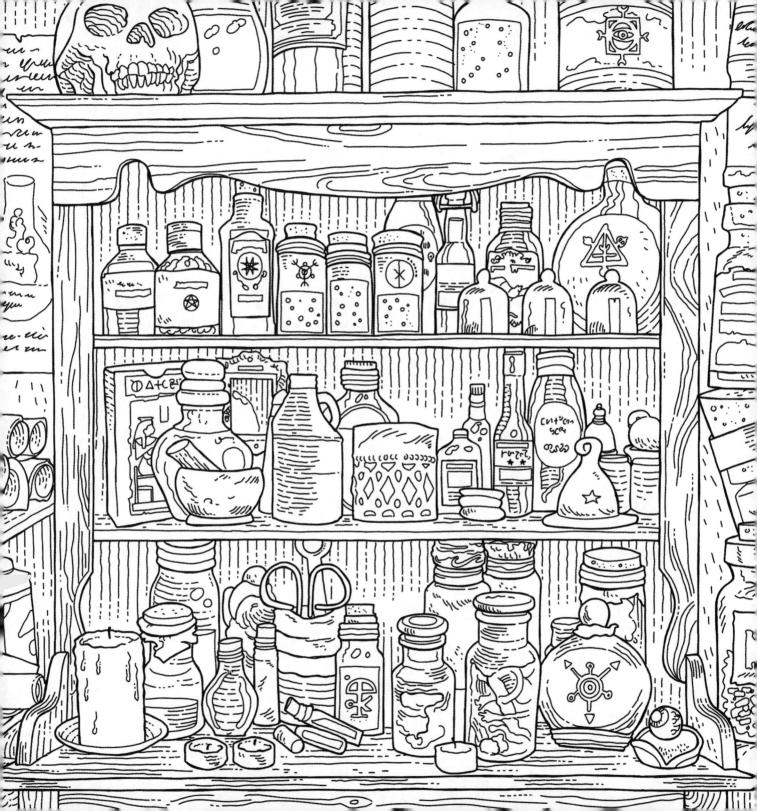

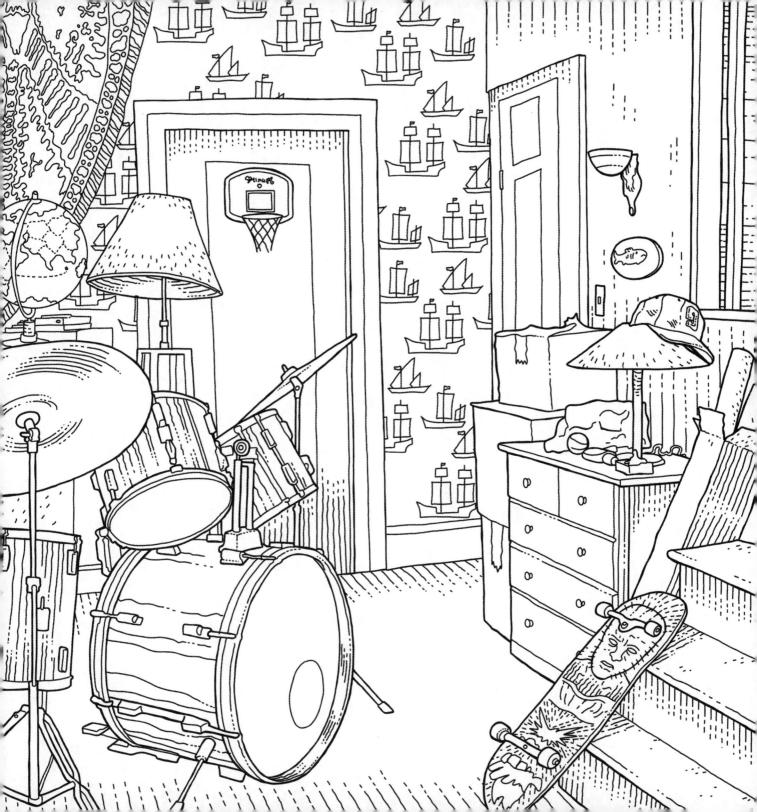

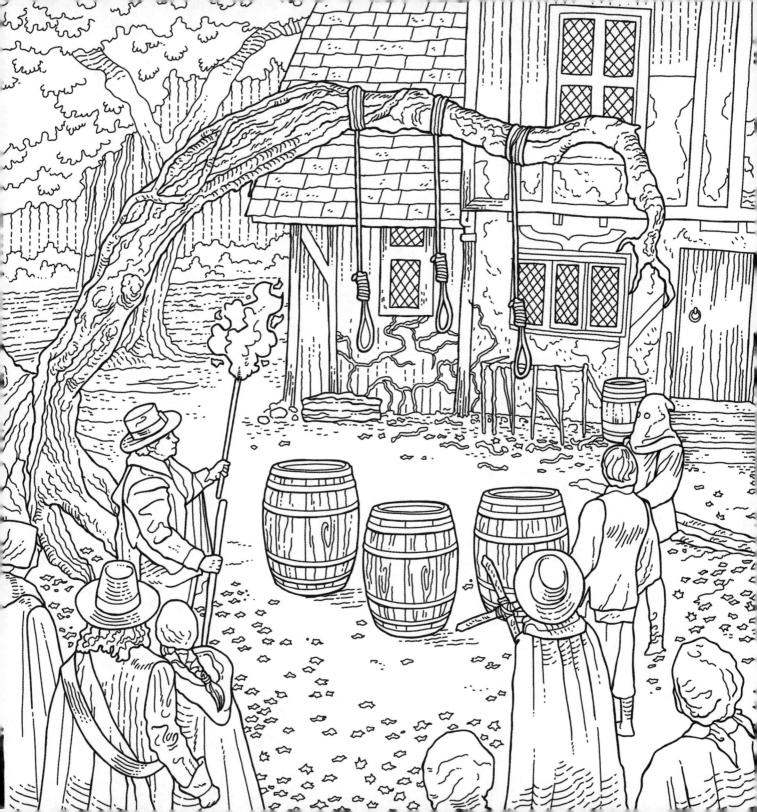

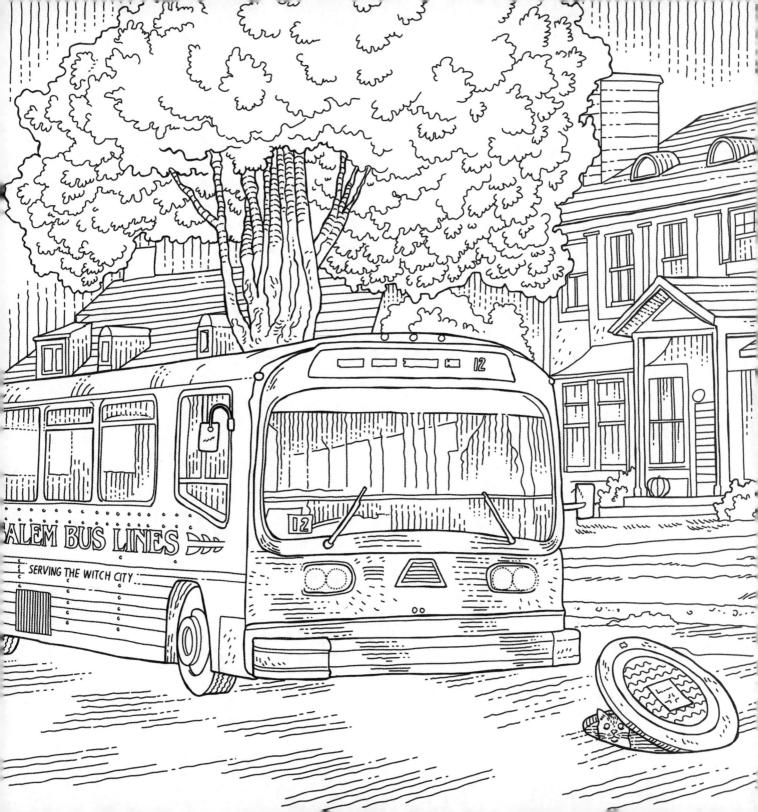

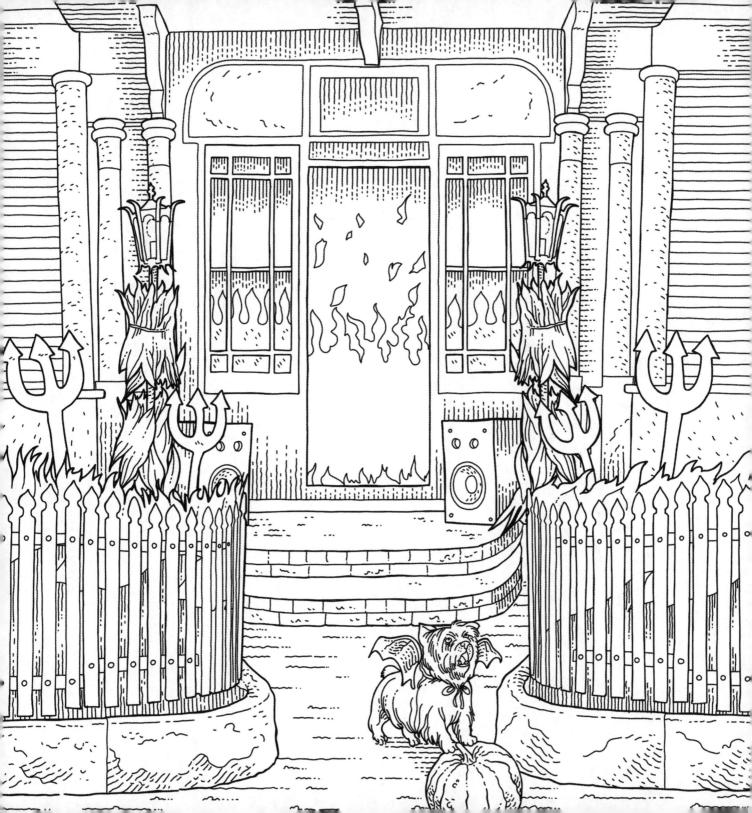

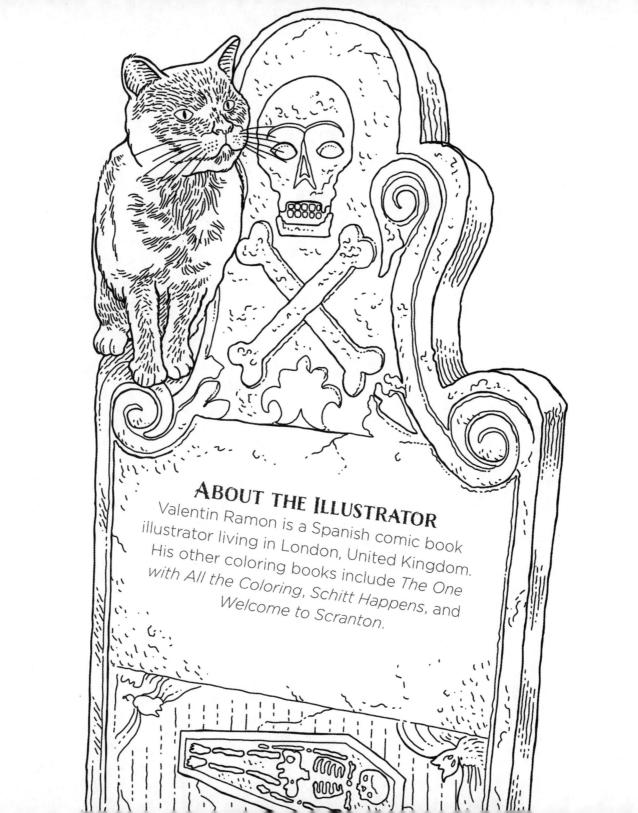

DISCOVER MORE GREAT COLORING BOOKS FROM ULYSSES PRESS

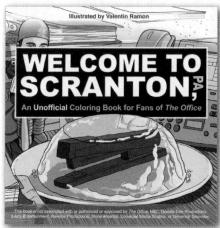

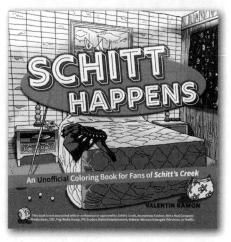

www.ulyssespress.com/coloring